GODS' MAN

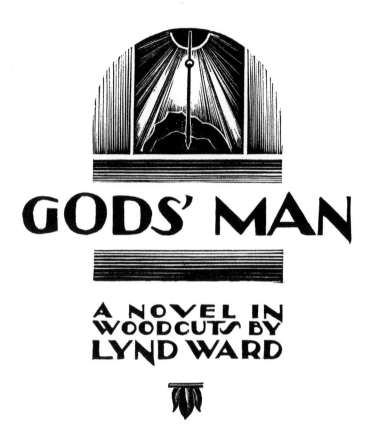

GODS' MAN

A NOVEL IN
WOODCUTS BY
LYND WARD

DOVER PUBLICATIONS, INC.
MINEOLA, NEW YORK

Bibliographical Note

This Dover edition, first published in 2004, is an unabridged republication of the work originally published in 1929 by Jonathan Cape and Harrison Smith, Inc., New York. The blank pages backing up the woodcut illustrations have been eliminated for this Dover edition.

Library of Congress Cataloging-in-Publication Data

Ward, Lynd, 1905–
 Gods' man : a novel in woodcuts / by Lynd Ward.
 p. cm.
 Originally published: New York : Jonathan Cape and Harrison Smith, Inc., 1929.
 ISBN-13: 978-0-486-43500-8 (pbk.)
 ISBN-10: 0-486-43500-8 (pbk.)
 1. Ward, Lynd, 1905– 2. Stories without words. I. Title: Novel in woodcuts.
II. Title.

NE1112.W37A4 2004
769.92—dc22

2003070013

Manufactured in the United States by LSC Communications
43500808 2018
www.doverpublications.com

TO
THEODORE MUELLER
JOHN HEINS
ALBERT HECKMAN

THE BRUSH

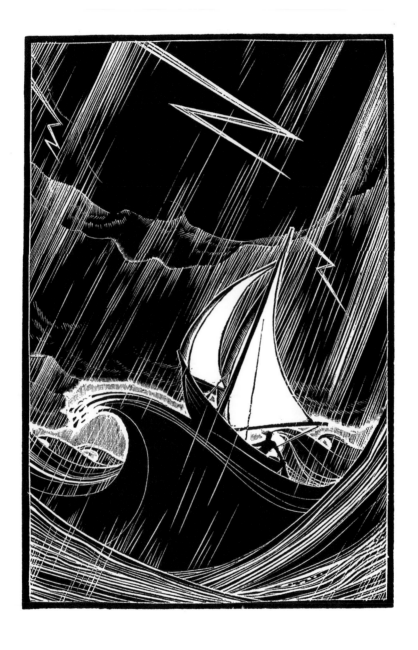

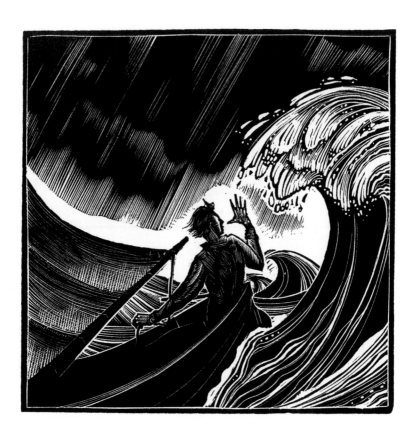

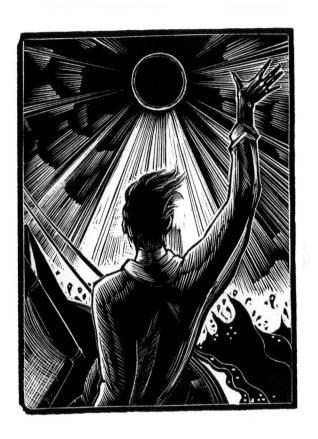

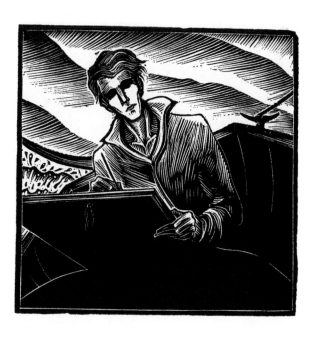

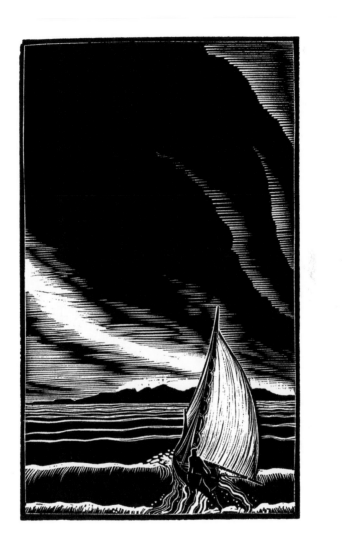

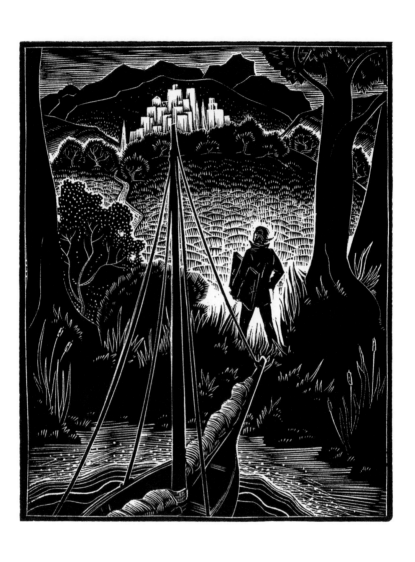

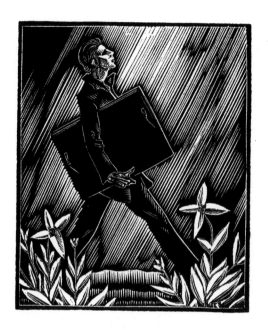

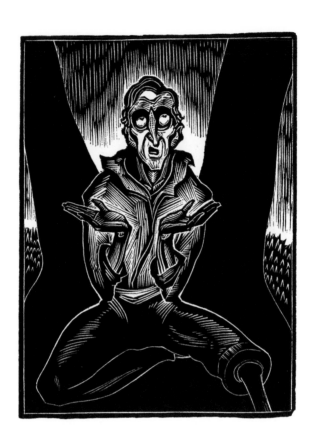

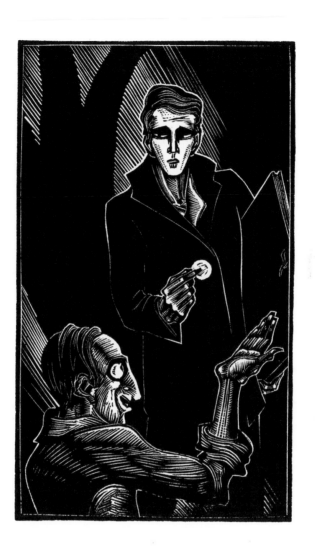

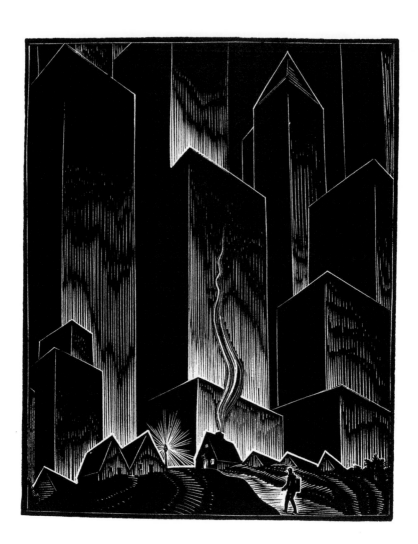

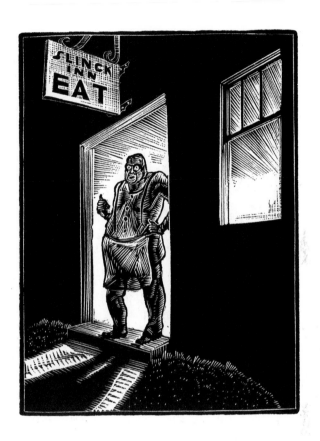

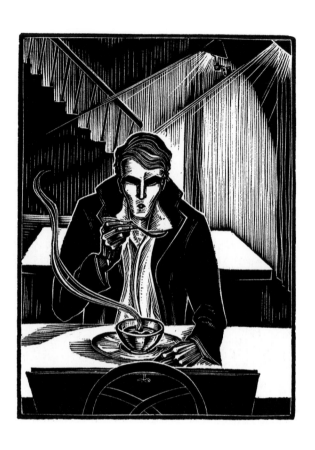

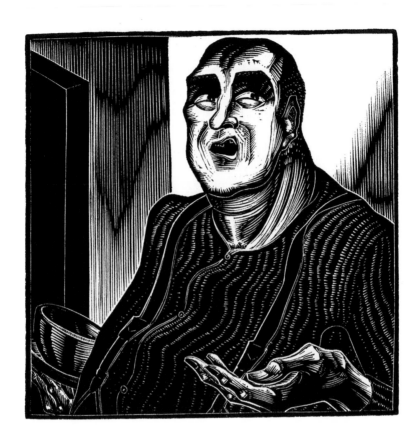

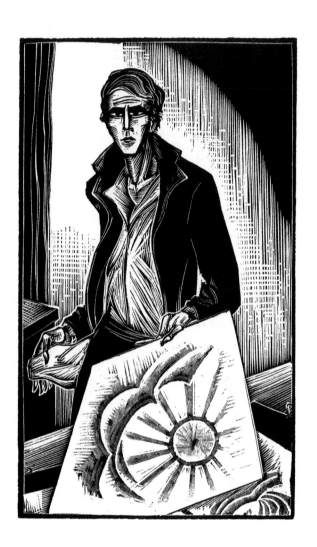

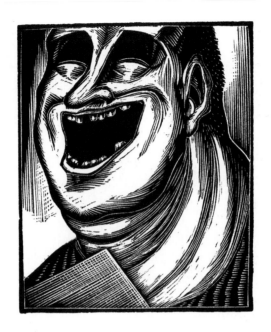

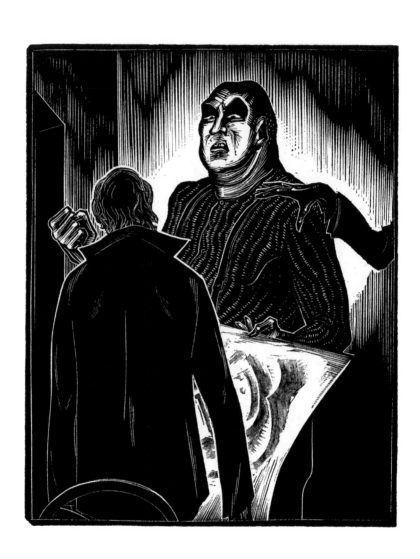

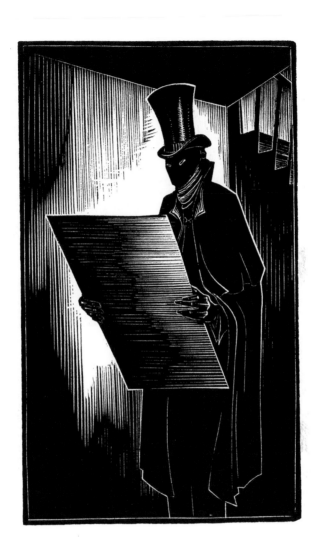

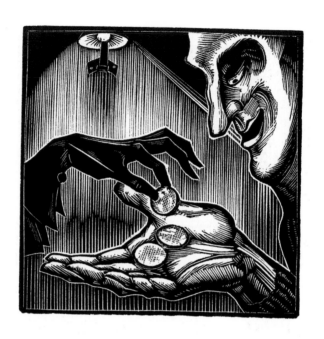

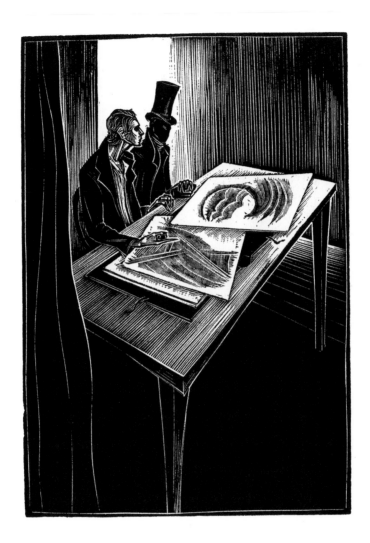

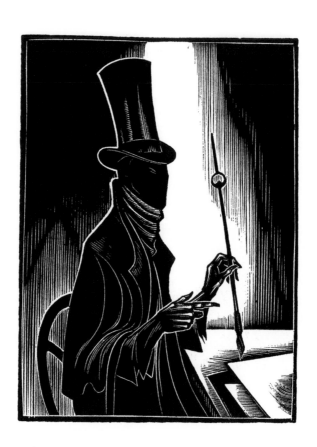

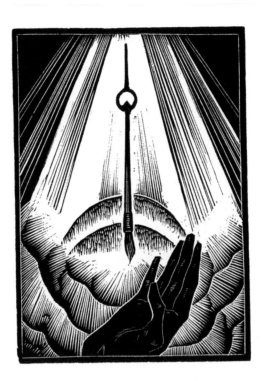

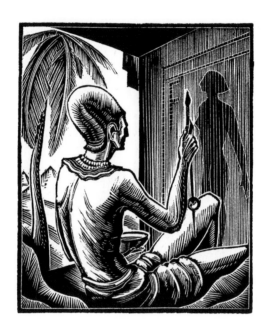

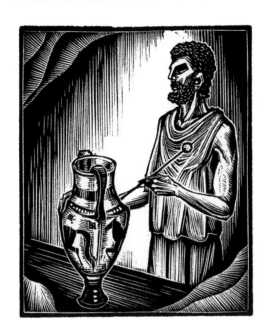

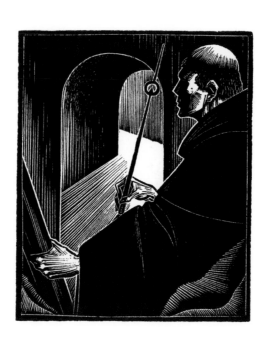

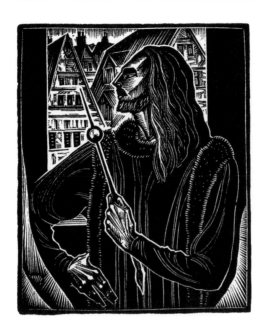

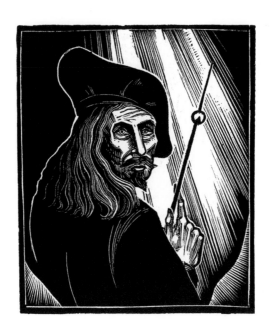

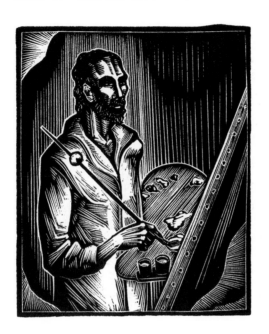

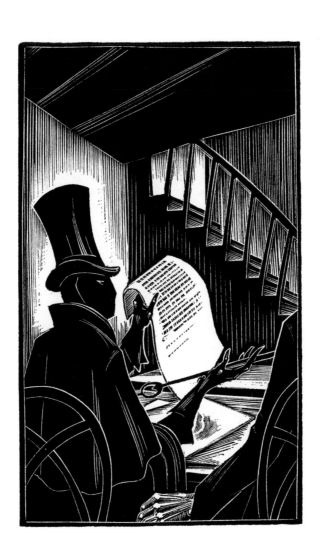

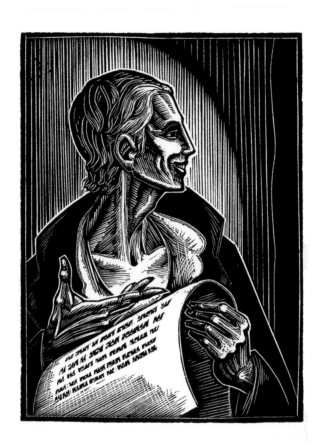

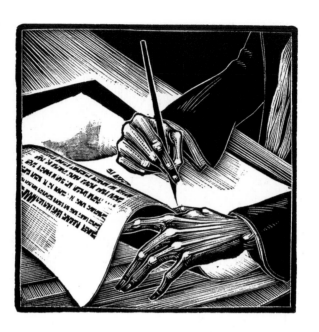

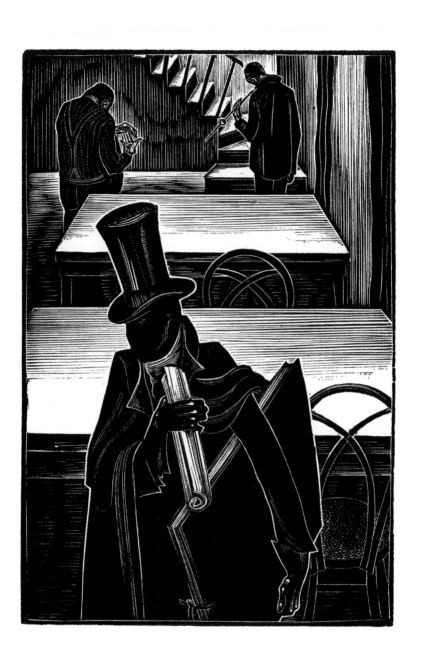

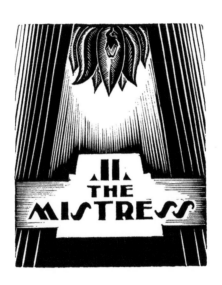

II.
THE
MISTRESS

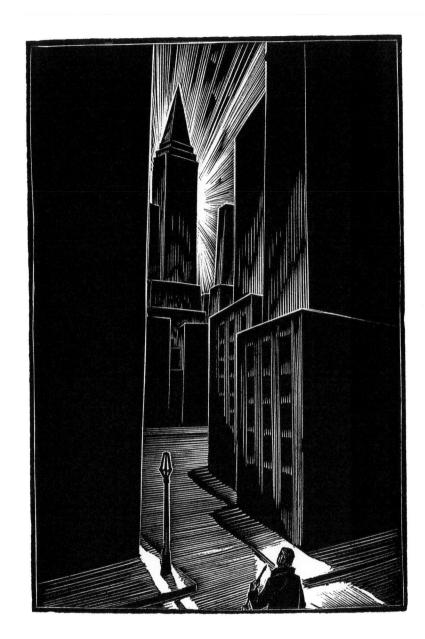

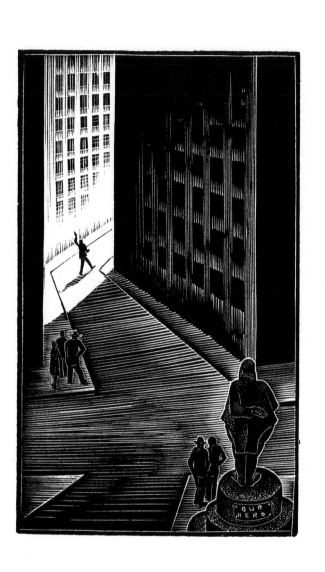

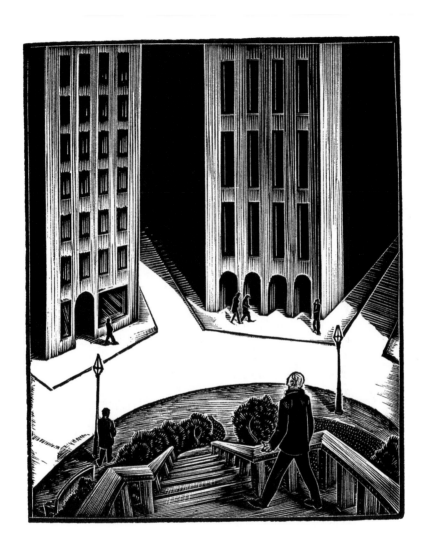

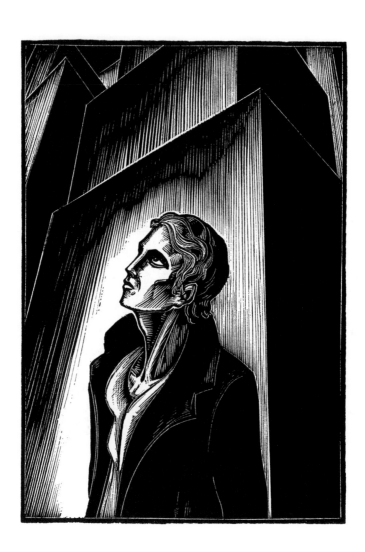

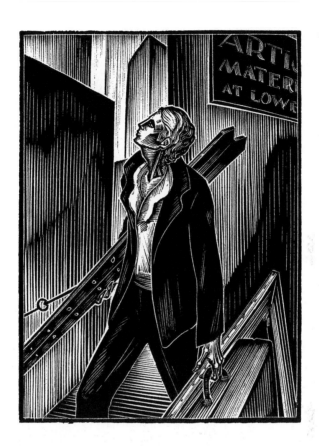

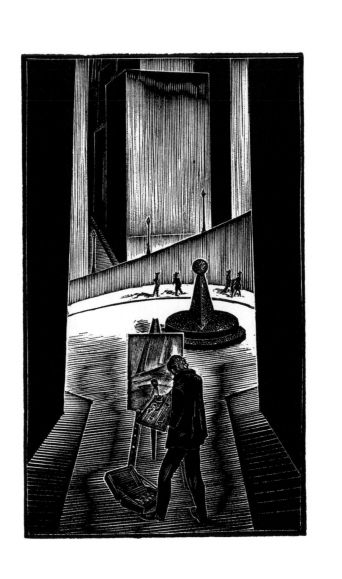

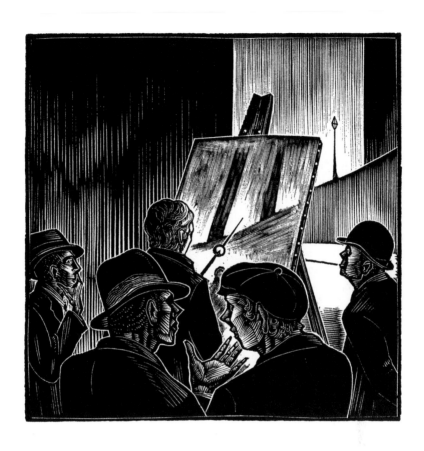

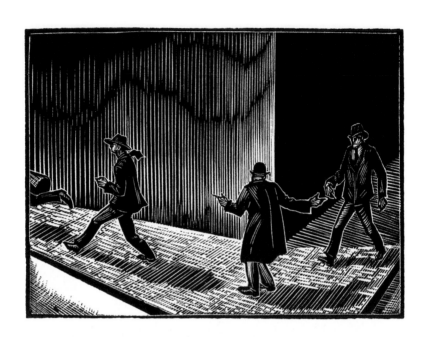

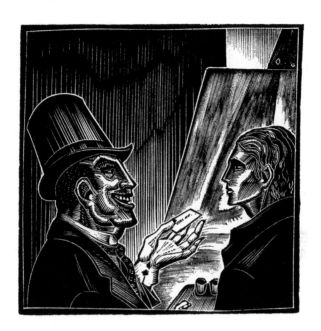

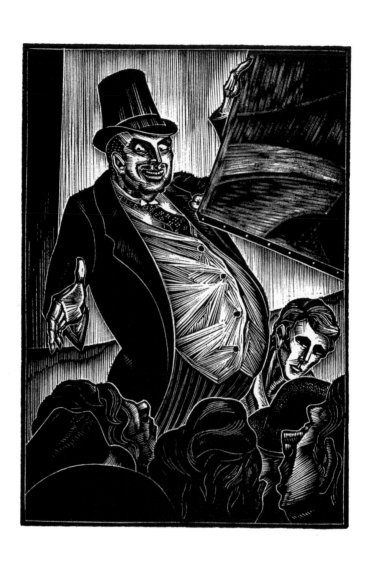

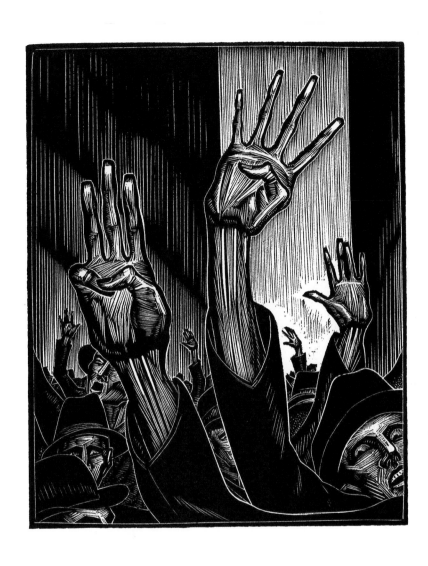

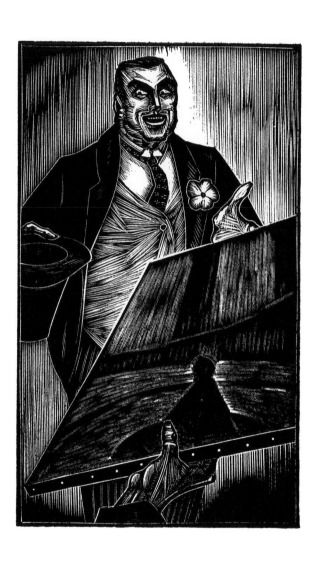

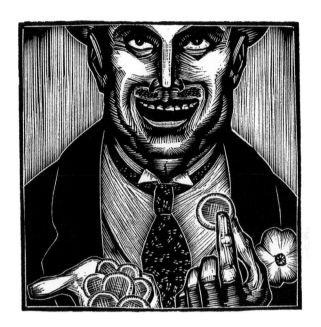

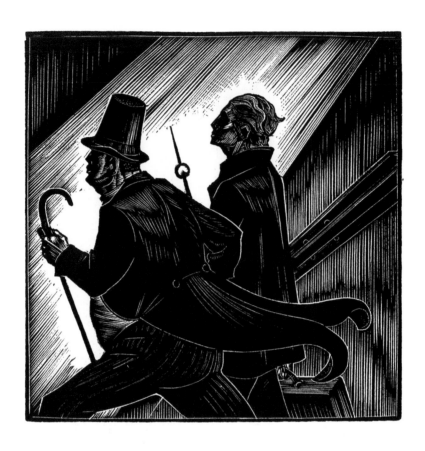

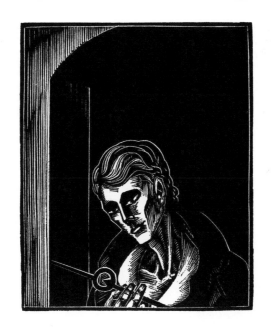

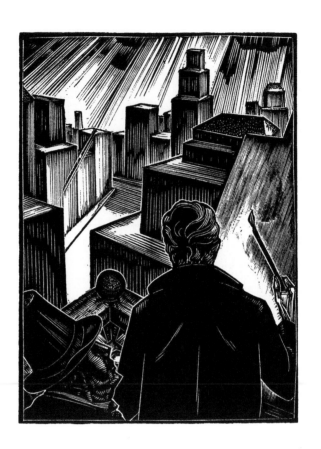

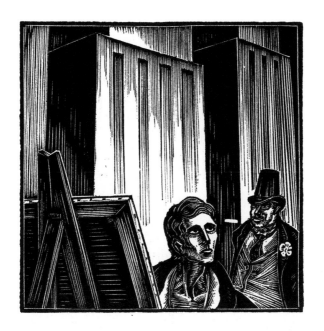

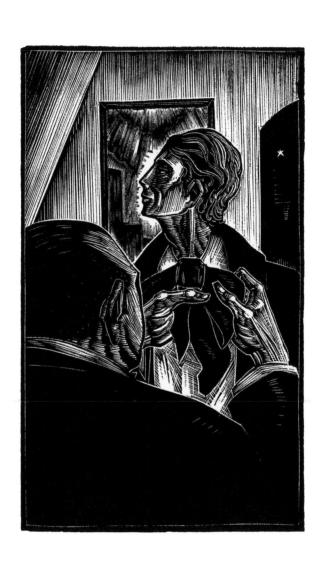

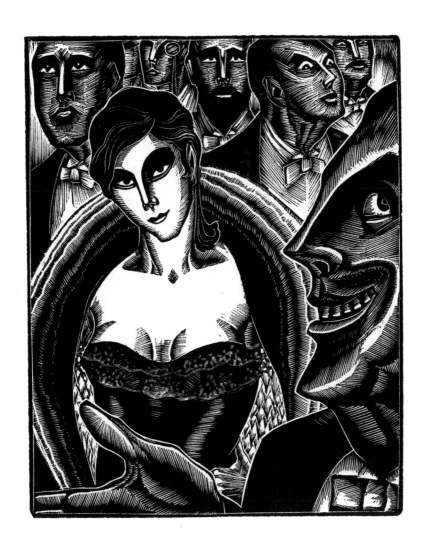

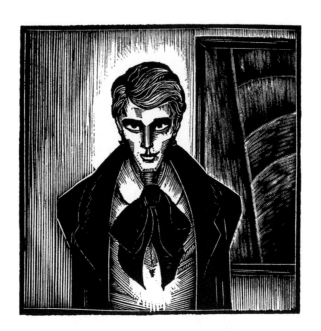

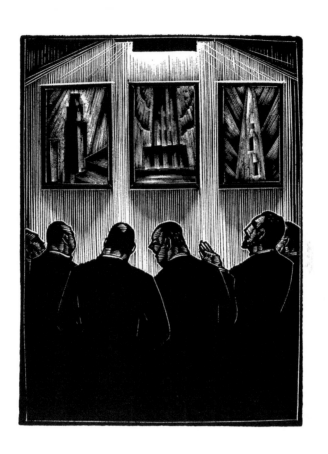

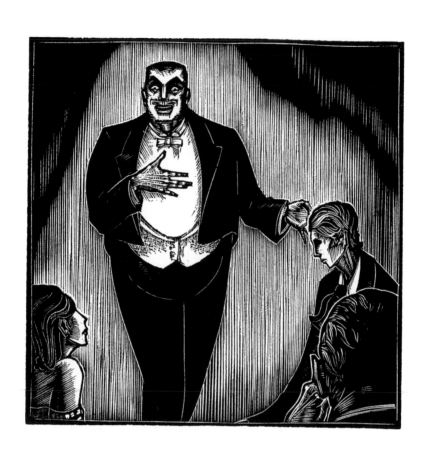

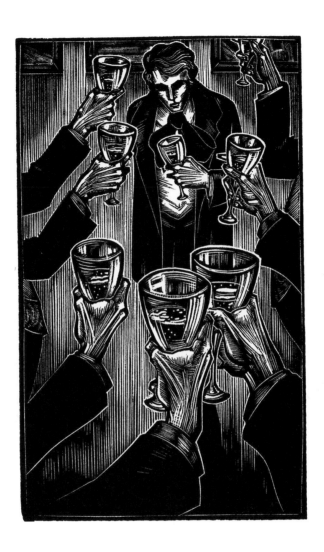

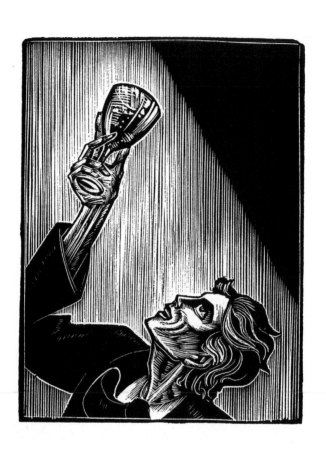

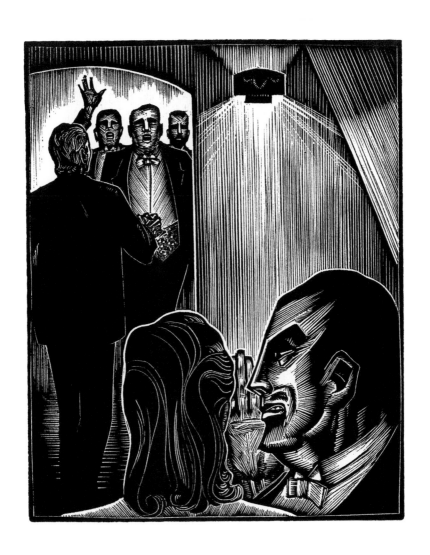

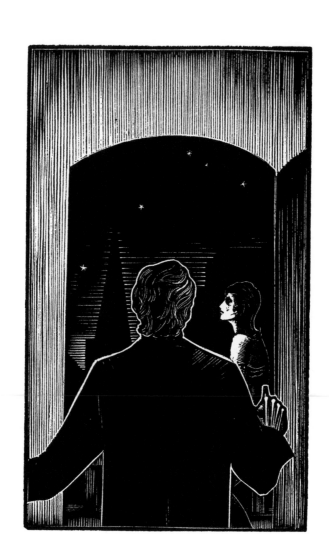

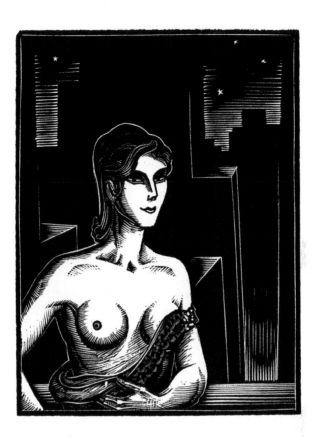

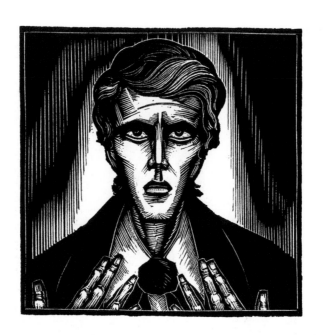

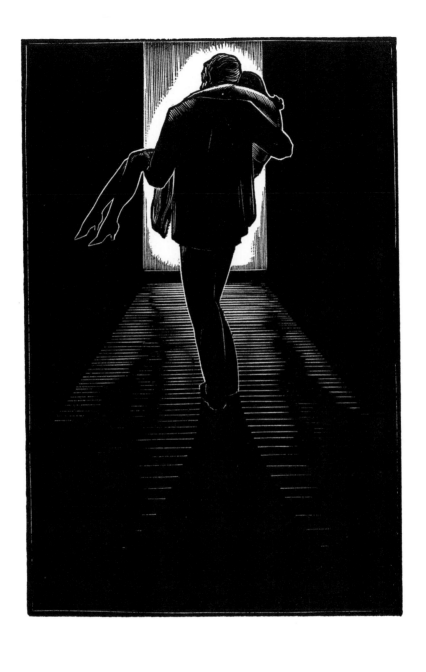

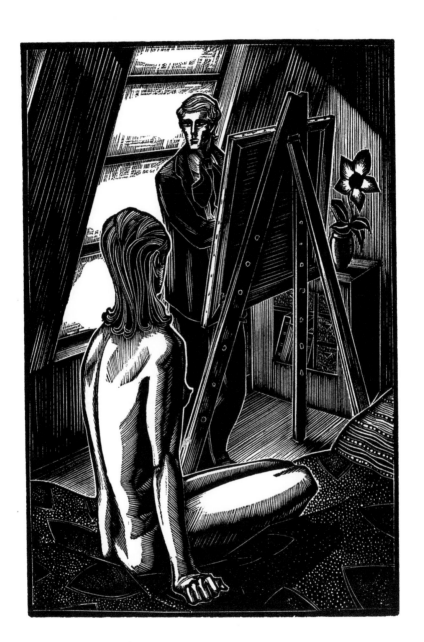

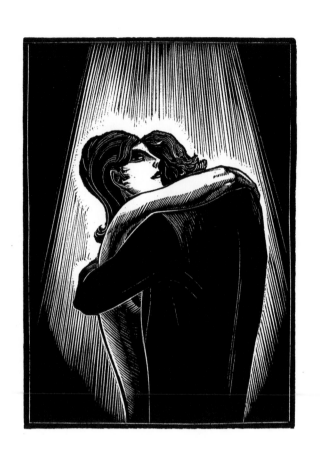

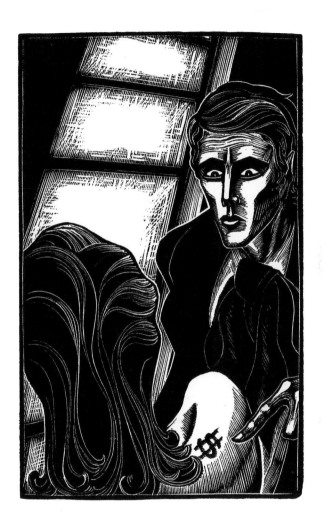

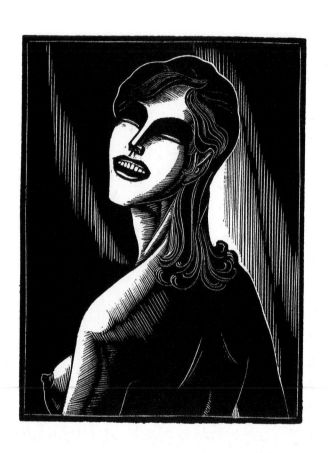

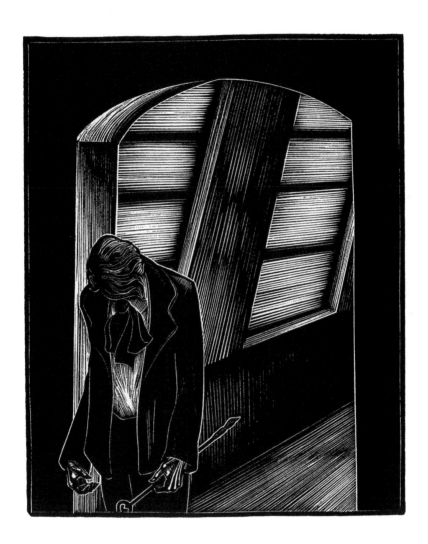

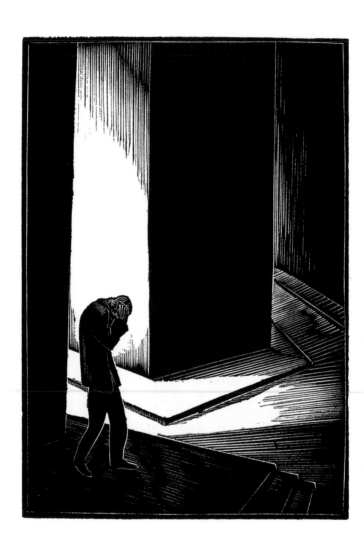

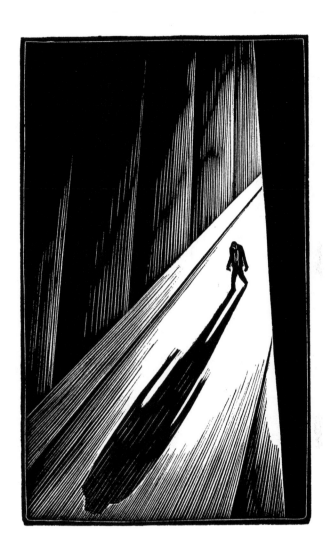

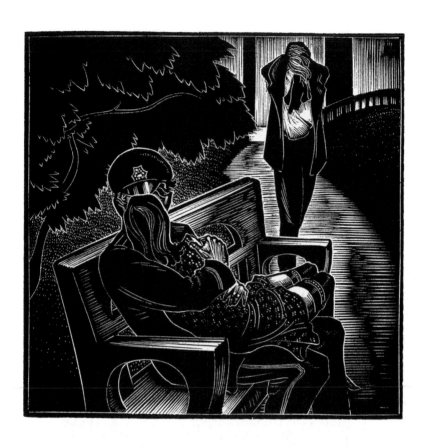

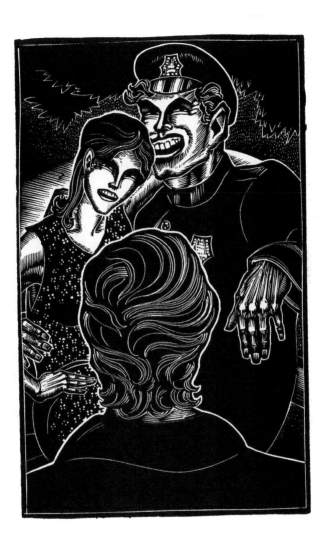

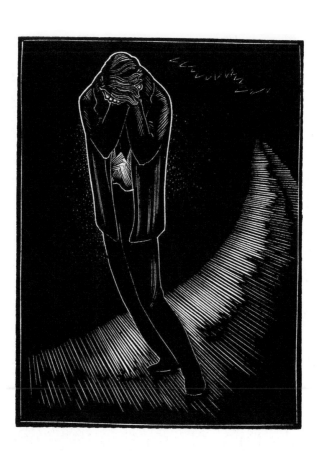

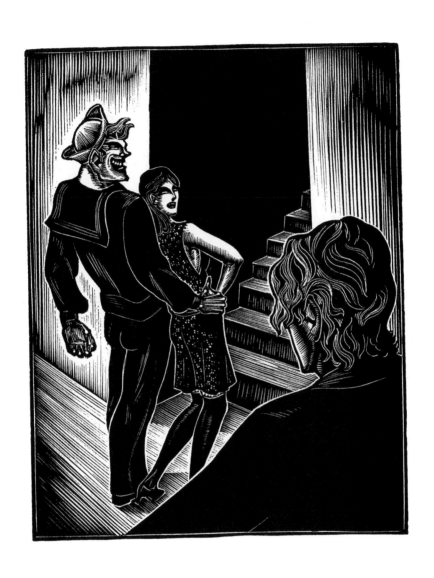

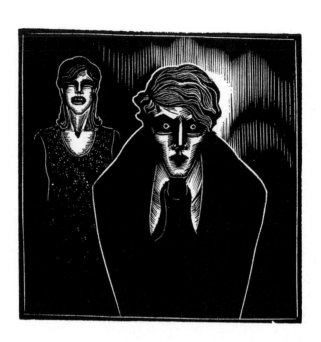

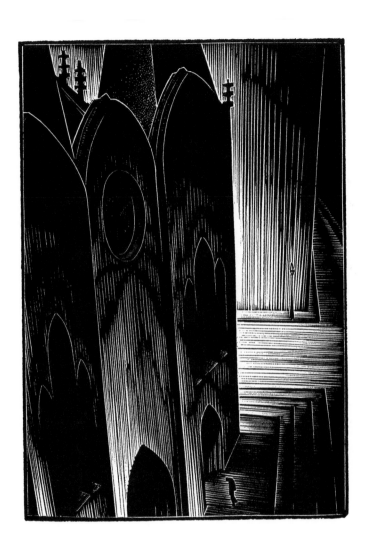

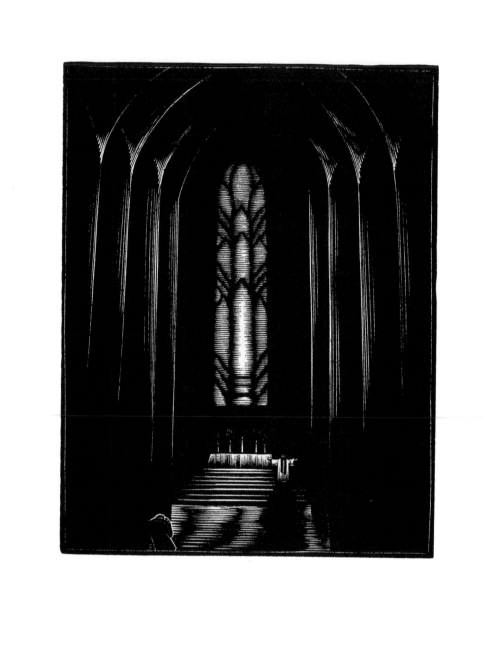

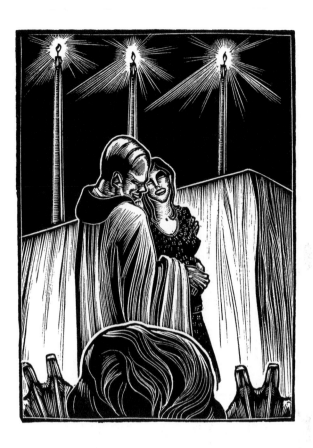

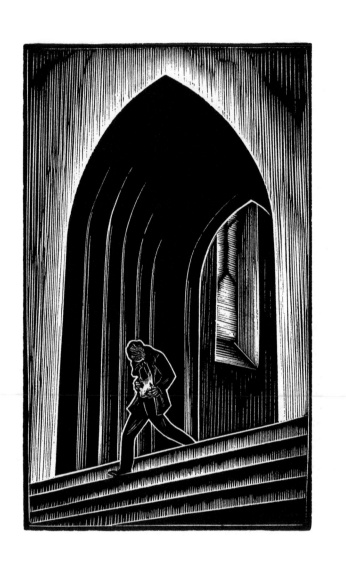

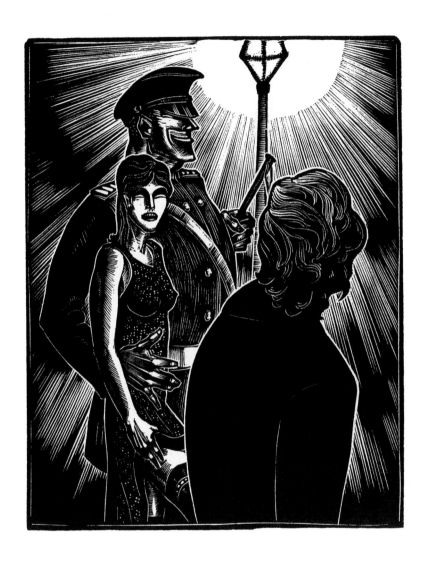

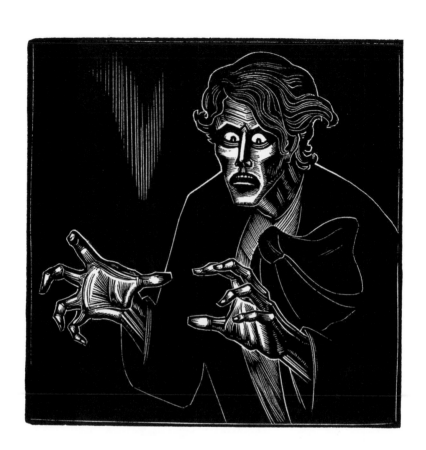

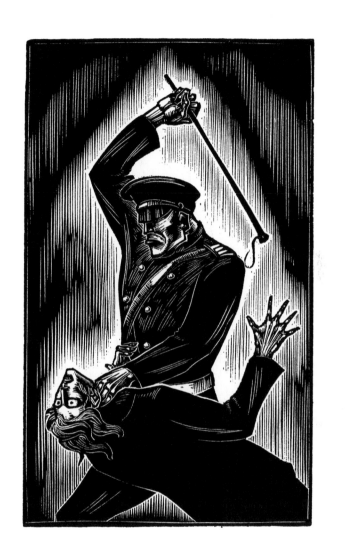

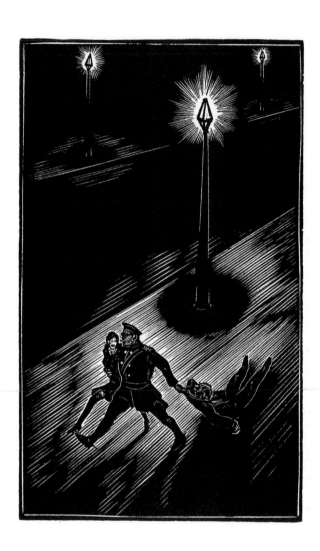

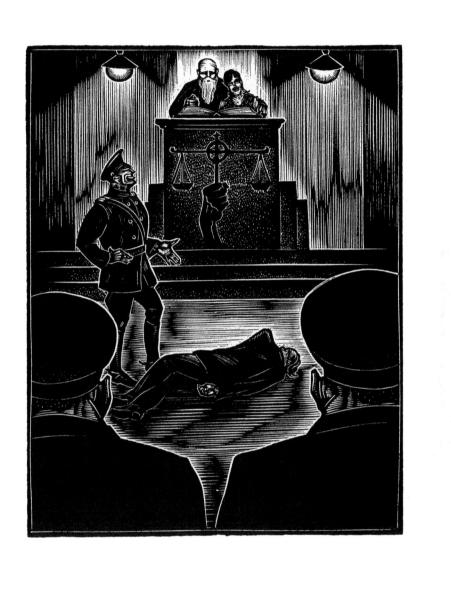

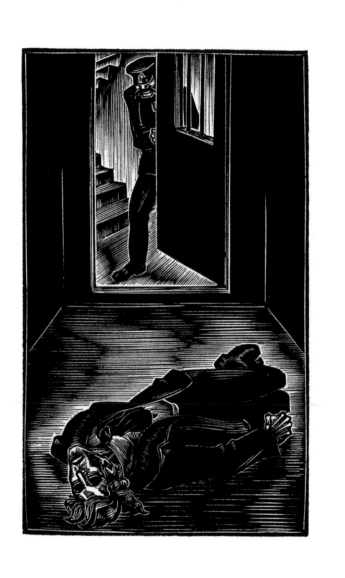

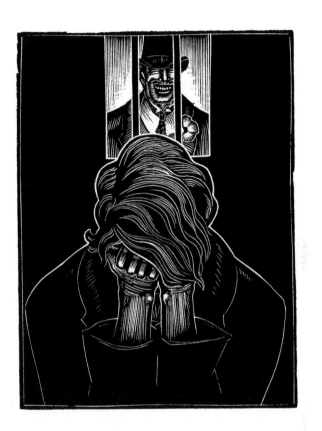

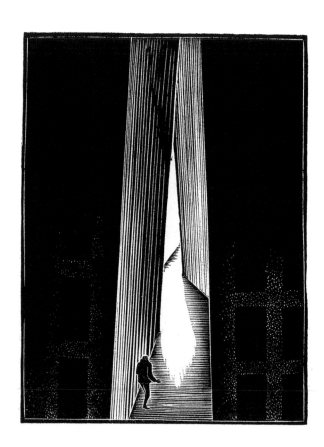

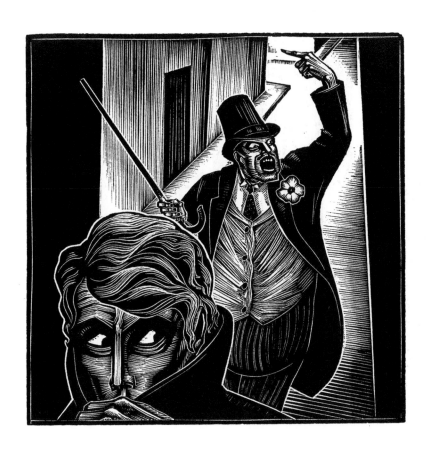

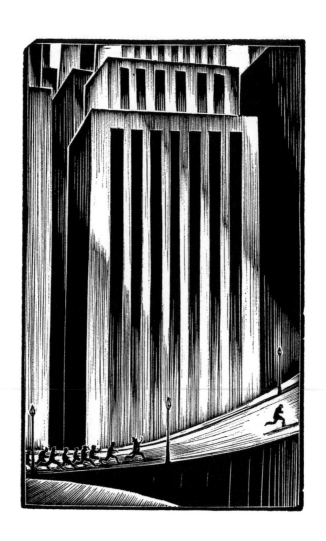

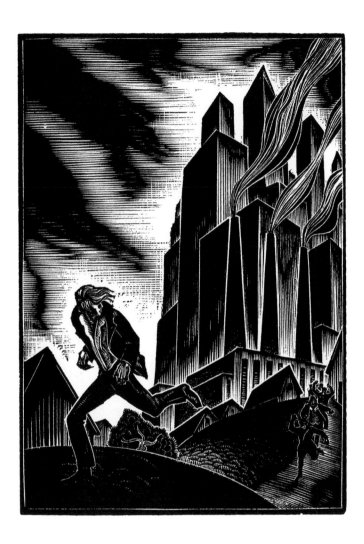

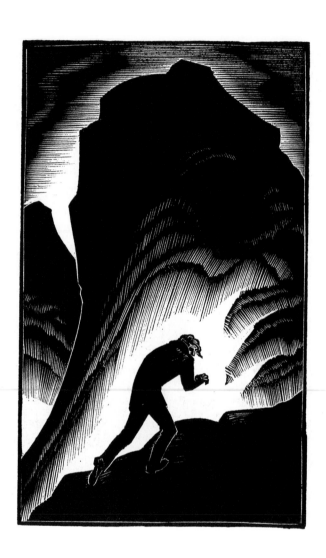

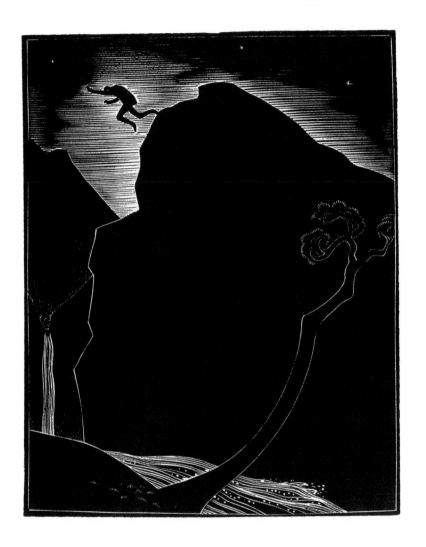

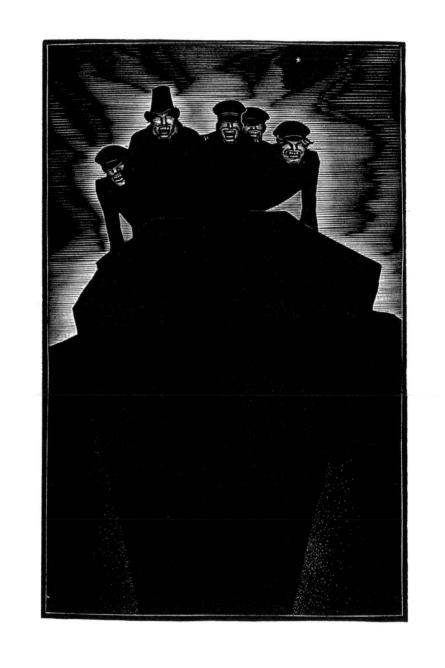

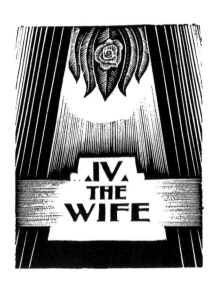

IV.
THE
WIFE

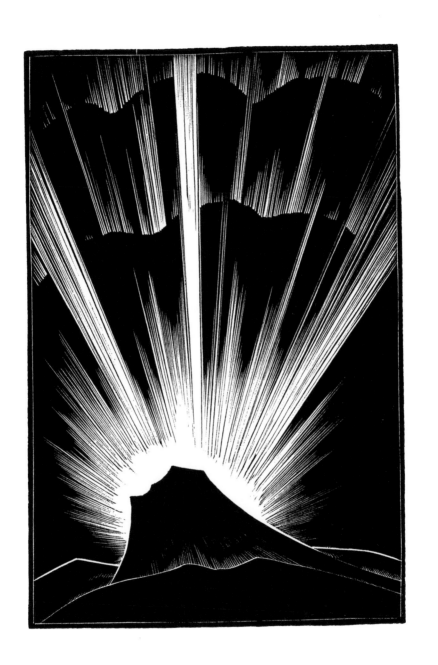

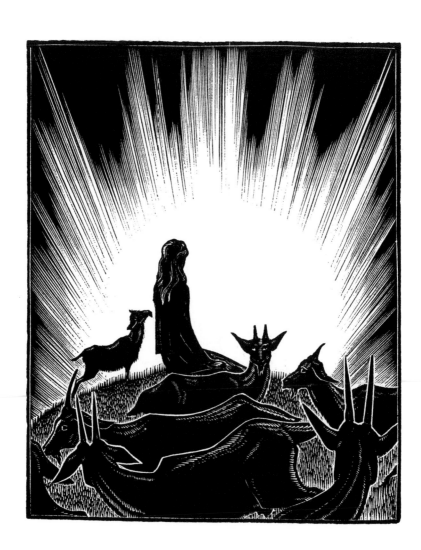

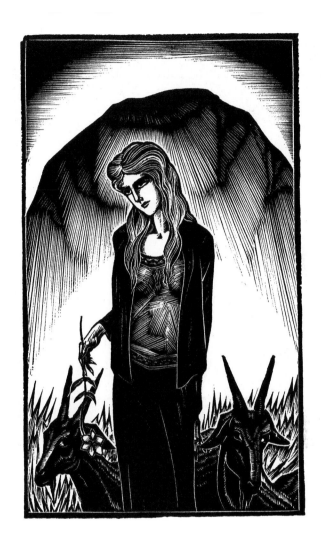

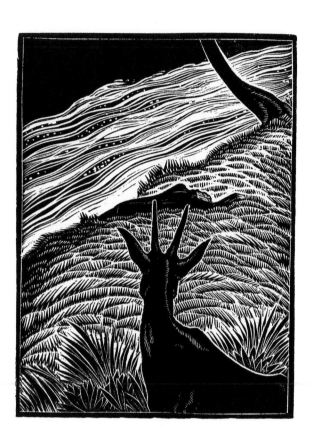

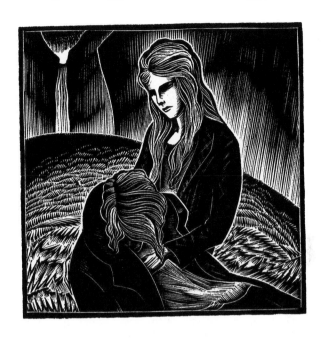

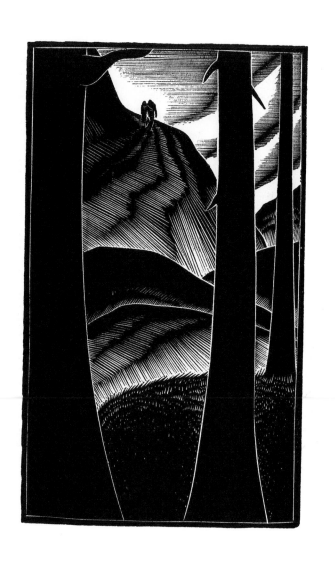

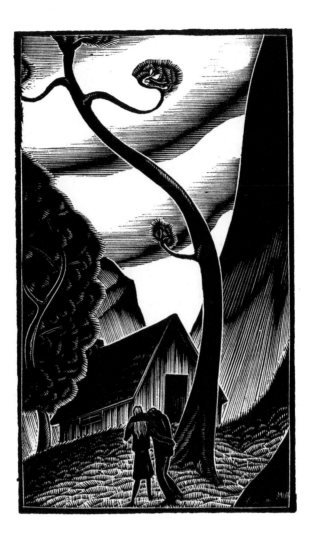

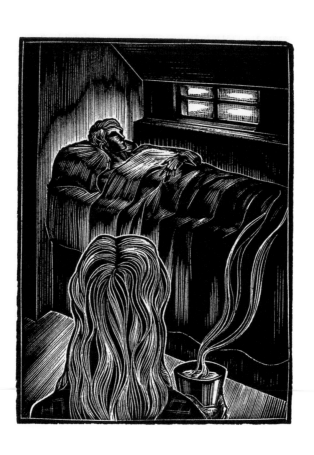

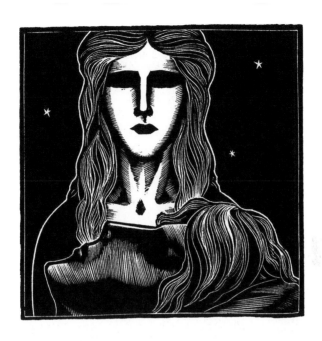

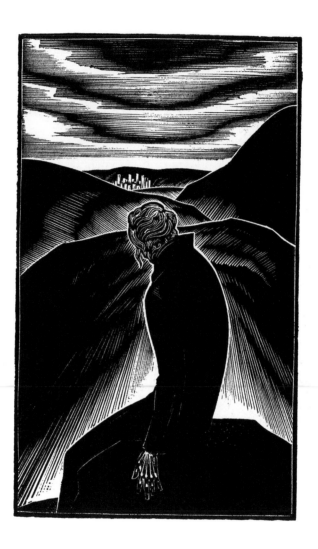

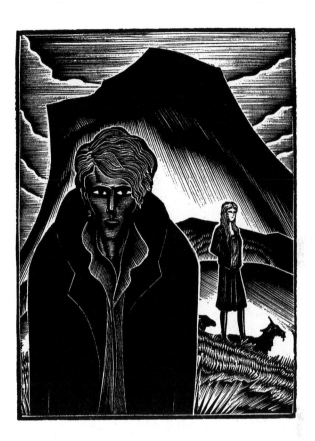

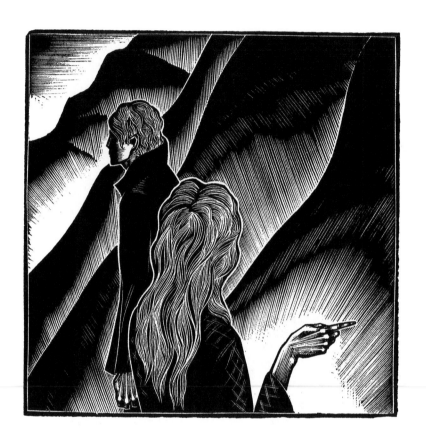

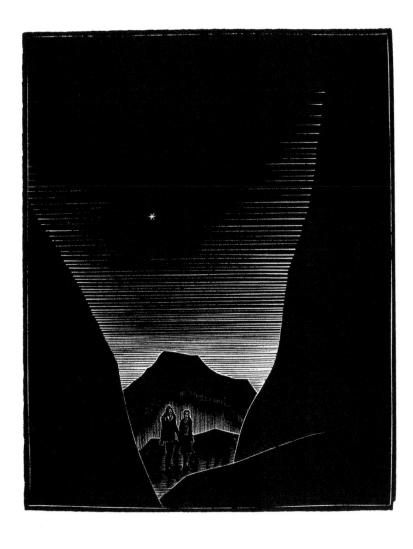

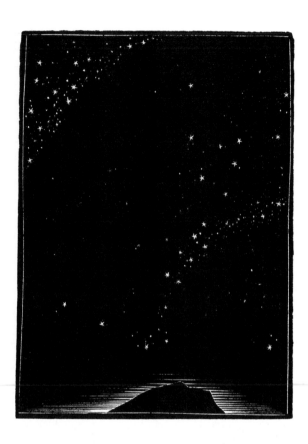

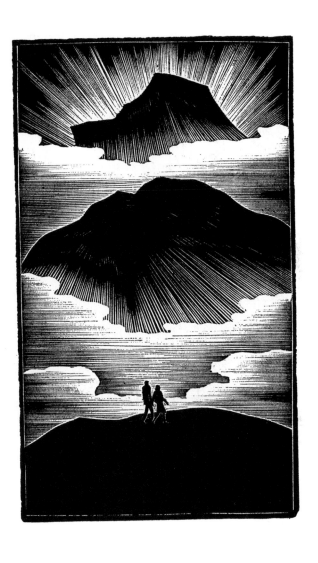

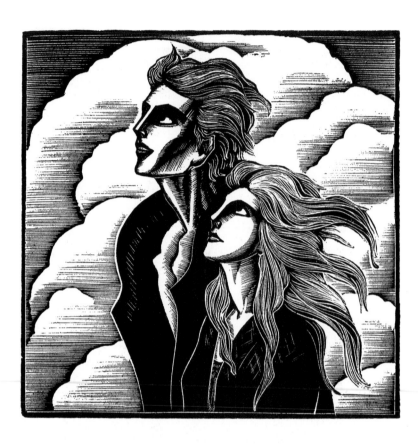

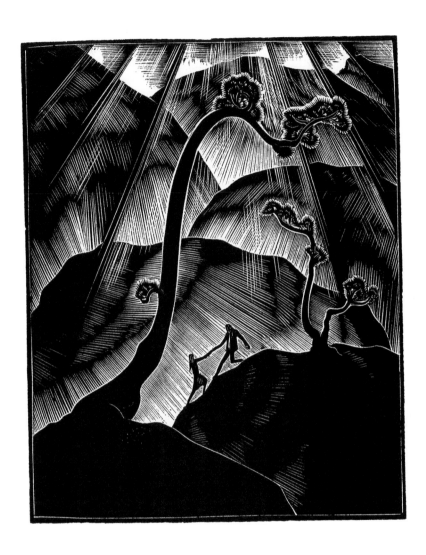

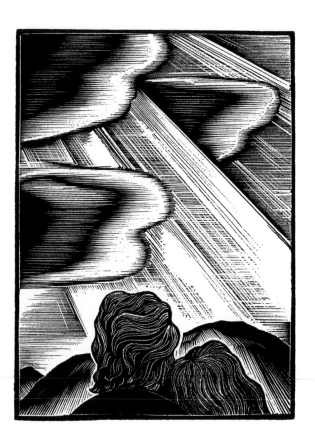

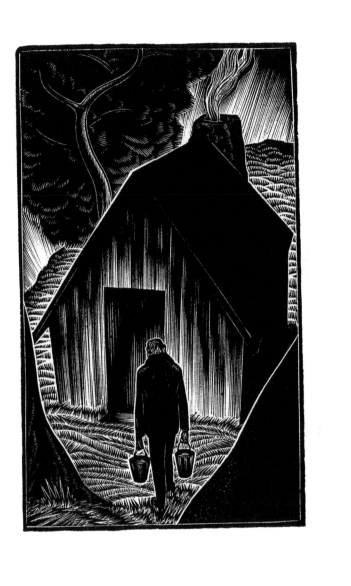

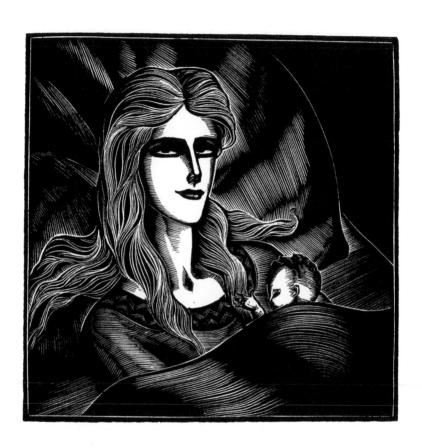

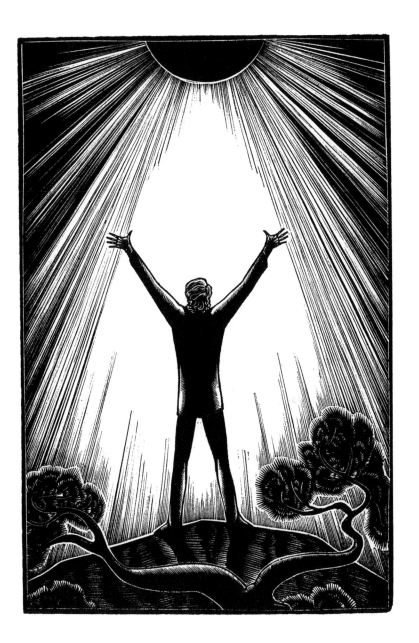

V. THE PORTRAIT

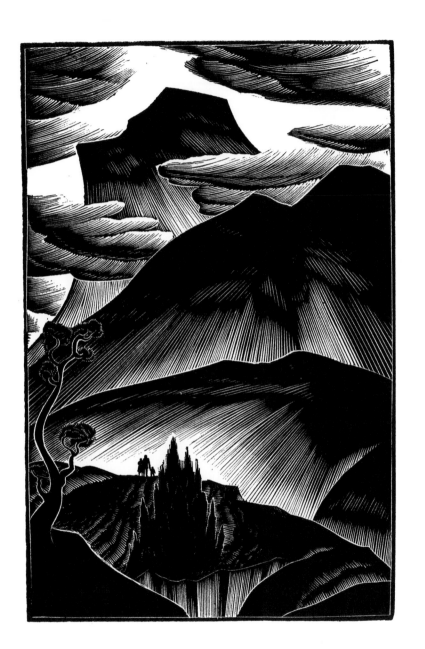

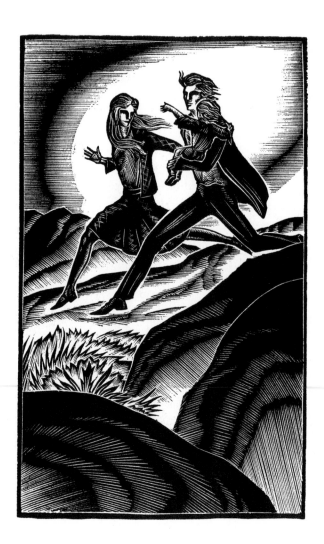

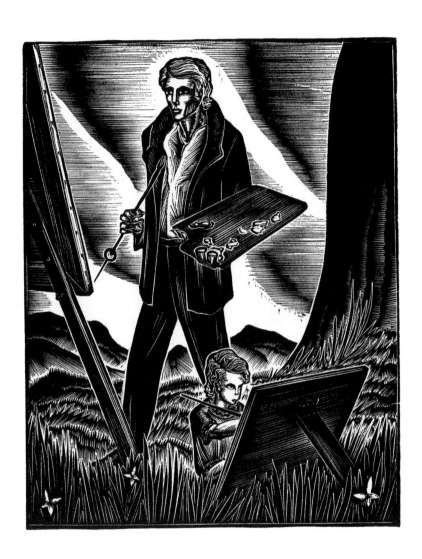

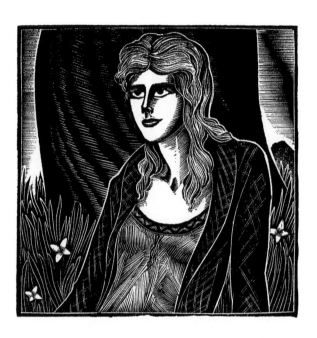

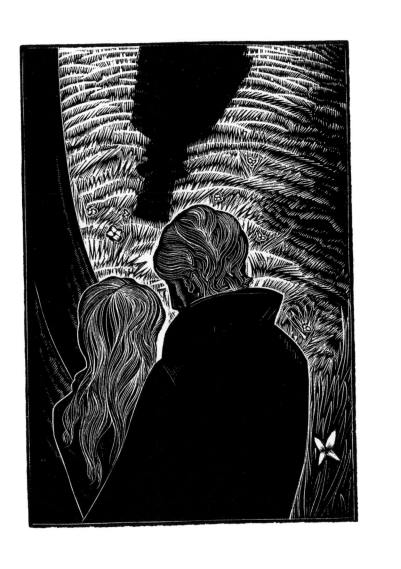

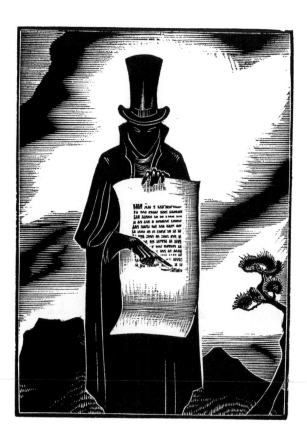

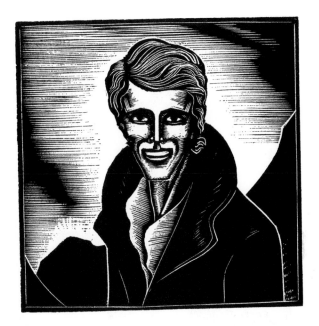

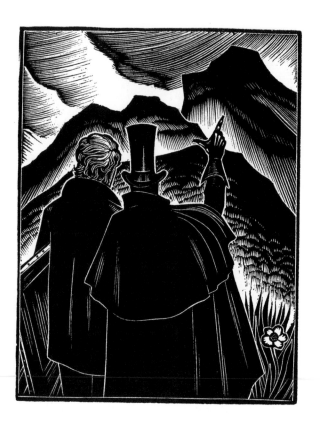

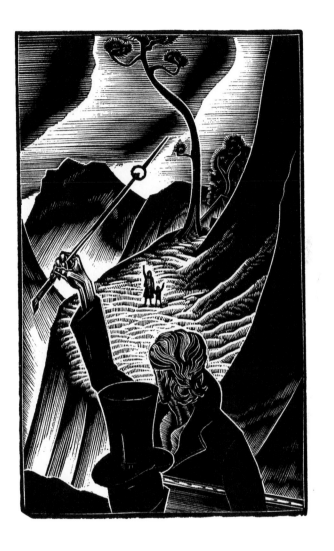

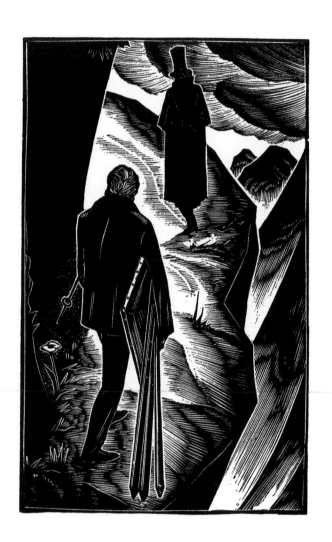

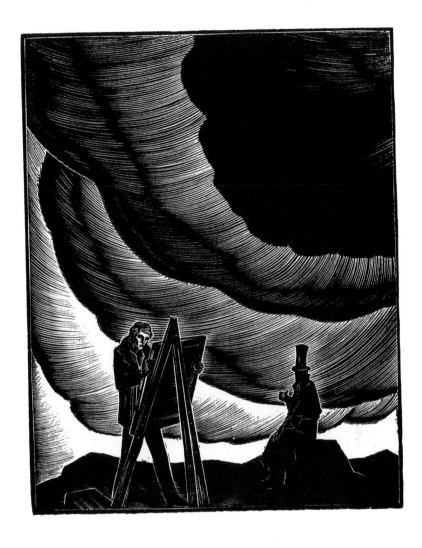

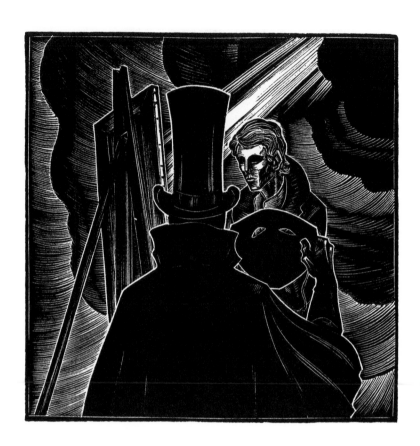

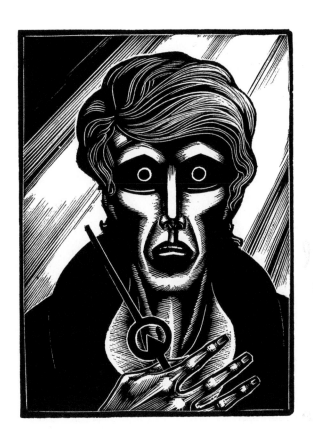

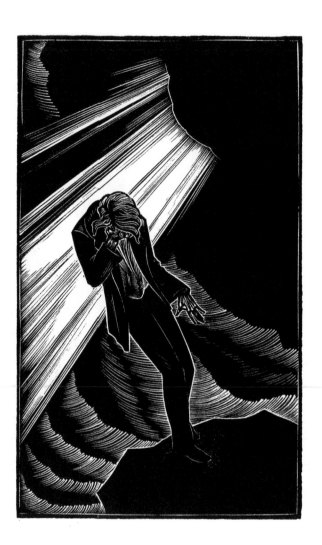

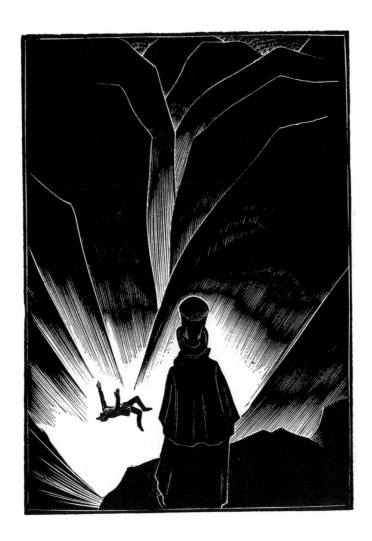

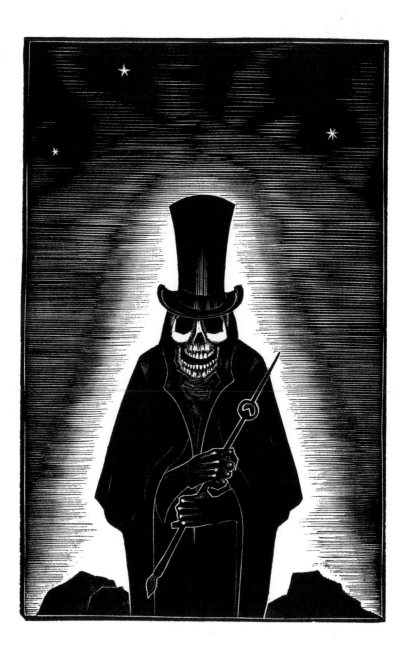